F

F

F

S
A

FAST
FASHION

Edited by Bibiana Obler
and Phyllis Rosenzweig

With essays by Kirsty Robertson
and Thuy Linh Nguyen Tu

SLOW
ART

Bowdoin

Contents

There is perhaps no form of personal
expression that defines us more rapidly
than the clothes we wear. These uniforms,
as it were, express our sense of self—our
professional role, leisure time versus
working hours, the causes we espouse, our
investment in ceremonies civic and religious.
But if those garments reflect something
deeply personal, what might they have
to teach us about the systems—political,
social, economic, and technological—that
went into their making? *Fast Fashion / Slow
Art*, carefully crafted by curators Bibiana
Obler and Phyllis Rosenzweig, pierces the
veil behind which our outfits take shape,
revealing, through the lens of contemporary
art, the competing fantasies and realities
of our wardrobes.

THROUGH THE JUDICIOUS SELECTION OF WORKS by nine artists, complemented by two documentaries, Obler and Rosenzweig provide an international perspective on the pitfalls of the inexpensive, even disposable, fashions that have become the hallmark of an industry geared toward mass production. Programs produced by National Public Radio in the United States and *Aftenposten* in Norway provide detailed information about the implications of contemporary textile production. Meanwhile, the works of artists such as Julia Brown, Martin de Thurah, Senga Nengudi, Hito Steyerl, and Wang Bing address the human cost of an industry that demands workers recalibrate their actions and sensibilities to mimic automated technology. Incorporating wry humor, Carole Frances Lung, Cat Mazza, Martha Rosler, and Rosemarie Trockel point at the absurdity—and incompatibility—implicit in translating the intimacy of human production to an industrial scale. The artists' use of temporally based strategies picks up on the rhythm of industrial production, while simultaneously laying bare the dizzying pace of contemporary life—our craving for continual change and the conditions necessary to satisfy that. As campus museums located in the former mill town of Brunswick, Maine, and the policy- and law-making hub of the United States, Washington, DC, we relish the importance of geography and intellectual reflection provided by our institutions—particularly in framing the larger significance of *Fast Fashion / Slow Art*.

We wish to express our deep appreciation to the many individuals and institutions that have made this important exhibition possible, foremost among them curators Bibi Obler and Phyllis Rosenzweig. We also thank the artists and contributors whose sensitive works and careful

analyses shed important light on an industry so deeply embedded in our lives as often to escape notice. For their kind assistance in facilitating the loans essential to this exhibition we thank Jonas Brenna, *Aftenposten*; Alice Conconi, Andrew Kreps Gallery; Michael Blair and Rebecca Cleman, Electronic Arts Intermix; Mindy Goldberg and David Traver, Epoch Films; Marie-Laure Gilles, Galerie Chantal Crousel, Paris; Michael Hahn, Galerie für Zeitgenössische Kunst Leipzig; Jenna Molster, National Public Radio; and Carla Donauer and Friederike Schuler, Sprüth Magers, Cologne.

Numerous individuals and organizations have made this project possible through generous financial support. In this spirit, we express our gratitude to the Center for Craft and the George Washington University's Columbian College of the Arts and Sciences for grants from its Humanities Facilitating Fund and its Columbian College Facilitating Fund. For making possible Bowdoin's participation, we wish to acknowledge the Riley P. Brewster '77 Fund for the Bowdoin College Museum of Art, the Stevens L. Frost Endowment Fund, and the Roy A. Hunt Foundation.

We deeply appreciate the outstanding editorial and production work on this catalogue overseen at Scala Arts Publishers, Inc. by Jennifer Norman and Hannah Bowen, as well as editor and project manager Magda Nakassis. We thank Antonio Alcalá and Ricky Altizer at Studio A for their sensitive and expert design.

We are indebted to the many colleagues at our respective institutions whose hard work and dedication have been critical to the successful realization of this exhibition. At the George Washington University, we thank Camille Ann Brewer, former Curator of Contemporary Art, for her early support of this project; we also recognize Stephanie Aboukasm, Doug Anderson, Susan Breitkopf, Olivia Desjardins, Jasmine Goodrich, Olivia Kohler-Maga, Tessa Lummis, Lenore Miller, Jillian Nakornthap, Jessica Schor, Richard Timpson, and Eliza Ward. At the Bowdoin College Museum of Art and Bowdoin College at large, we acknowledge Suzanne Bergeron, Leslie Bird, Allison Crosscup, Frank H. Goodyear, Susan Harrison, Michelle Henning, Jo Hluska, Laura Latman, and José Ribas. As always, we are grateful for the support of the leaders at our respective institutions: at the George Washington University, President Thomas LeBlanc, Interim Dean of the Columbian College of Arts and Sciences,

Paul Wahlbeck, and Director of the Corcoran School of the Arts and Design, Sanjit Sethi; and at Bowdoin College, President Clayton S. Rose and Dean for Academic Affairs Elizabeth McCormack.

Finally, on behalf of the curators, we express special gratitude to Arthur Foster for his diligent work on behalf of this publication and to Elissa Auther, Alan Wallach, Suzanne, Veronica, and Felix for their professional and personal encouragement.

Anne Collins Goodyear
Co-Director, Bowdoin College Museum of Art

John Wetenhall
Director, The George Washington University Museum and The Textile Museum

Introduction

Bibiana Obler and
Phyllis Rosenzweig

Fast Fashion / Slow Art, both as exhibition and catalogue, aims to catalyze broad-ranging conversations about issues related to the global production and distribution of textiles. What are the merits of the local and tailor-made versus the mass production of fast fashion? Is it possible to protect workers' rights and ensure safe working conditions while keeping up with consumer demands? How does technology affect the experience and conditions of labor? What skills do the mass production of textiles require? Can design and technology offer sustainable solutions to the environmental effects of fast fashion? What role do art and popular culture have in raising consumer consciousness?

ARTISTS, FILMMAKERS, ECONOMISTS, labor activists, conscientious consumers, corporate lobbyists, and others have been studying and discussing textile production and distribution for decades. It was the cotton mills, after all, that sparked the Industrial Revolution. *Fast Fashion / Slow Art* focuses on the particularities of garment industries' operations in this age of fast fashion. The quantity of production, the environmental effects of the global movement of raw and manufactured goods, the implications—so far mostly negative—of new technologies (such as fabrics that combine synthetic and organic materials), and the scale of waste have produced a crisis qualitatively different from that which spurred Karl Marx and Friedrich Engels to formulate *The Communist Manifesto*. Labor conditions continue to constitute violence against workers—now especially women—but the combination of technological "innovations" with the speed and scale of moving goods, and the complicated trade politics between nations, have created new challenges.

It is beyond the scope of this exhibition and catalogue to provide a comprehensive analysis of fast fashion in the twenty-first century. Rather, the works by artists and filmmakers in this show—through metaphor, poetic sensibility, irony, protest, and humor—ask us to slow down and consider the complexities of various issues surrounding the garment industry and its embeddedness in everyday lives.

"Fast fashion" refers to a mode of production, distribution, and marketing that creates and feeds an appetite for the frequent consumption and discarding of clothing. Supplying inexpensive, yet stylish, garments became a leading business model in the 1990s: by restocking stores with new and incredibly cheap options, sometimes as often as twice a week,

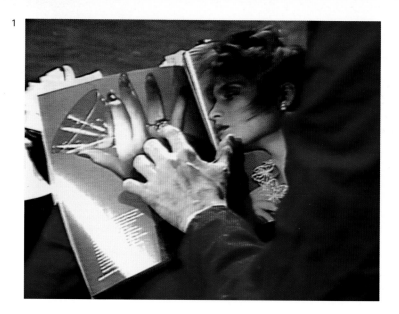

1

Fig. 1. Martha Rosler, *Martha Rosler Reads "Vogue,"* 1982, video, color, sound, 25:22 minutes. Courtesy Electronic Arts Intermix (EAI), New York.

clothing companies encouraged constant and binge consumption. The system relies on poor-quality, high-speed manufacture and low wages, as well as highly networked connectivity that allows for last-minute design decisions communicated to factories scattered across the globe.[1] "Fast fashion" is just the latest incarnation of the pleasures and ills associated with garment production. Already it shows signs of yielding to a slowly increasing desire, on the part of consumers, for well-made garments that have at least some claim to sustainability and being "woke."

The videos in *Fast Fashion / Slow Art* coincide with the rise—and perhaps incipient waning—of fast fashion. They address this stage in the history of the garment industry in diverse ways, but they all play with the documentary form, injecting it with performance and fiction, the better to get at the truth of their subjects. In "The Painter of Modern Life," Charles Baudelaire defined modernity with fashion in mind: the eponymous artist "makes it his business to extract from fashion whatever element it may contain of poetry within history, to distil the eternal from the transitory."[2] Likewise these videos represent the beauty and ugliness of the millennial moment—how this period's struggles are distinctive, but also belong to the ever-lengthening history of modernity.

Is it you?

Martha Rosler's now classic *Martha Rosler Reads "Vogue"* (fig. 1) introduces many of the themes in the show: the divide between the privilege associated with fashion and the adverse conditions of sweatshop laborers; murky relations between fashion and art patronage; and the call for viewers to realize their own complicity. Rosler dedicates most of her twenty-five-minute video to a deadpan feminist critique focused on *Vogue* magazine. In a short musical interlude to the tune of Blondie's "Die Young Stay Pretty," she presents footage from a sweatshop, presumably in New York's Chinatown, accompanied by statistics on garment production: "Over 40% of clothes sold in the US are made in the Third World. Most of the rest are made in Third World enclaves in NYC, Miami, Chicago, and L.A." At that time, in 1982, the US garment industry was still in a relatively early stage of its seismic shift away from primarily US-based production. In 1965, less than 5 percent of clothing sold in the United States was made abroad. Recent statistics indicate that the opposite is now the case—about 97 percent is made abroad—although the tide may be slowly reversing.[3]

Many of the videos in the exhibition not only take up issues broached by Rosler but also relate to her tactics. In *Lovely Andrea* (fig. 2), Hito Steyerl combines footage from multiple sources and inserts herself into

Fig. 2. Hito Steyerl, *Lovely Andrea*, 2007, single-channel video, color, sound in English, Japanese, and German with English subtitles, 30 minutes. Courtesy of the artist and Andrew Kreps Gallery, New York. Image CC 4.0 Steyerl.

Fig. 3. Julia Brown, *Live feed; printer-error identification station and operator at an Italian luxury-silk textile factory; Or, before "Leaving the Factory," the meditative disposition's instinct for privacy,* 2010, HD color video, sound, 2:49 minute loop. Courtesy of the artist.

Fig. 4. Carole Frances Lung, *Frau Fiber and Bob standing in front of a ring spinner at Echoview Fiber Mill, Weaverville, North Carolina,* taken on-site during filming of *Frau Fiber vs. The Ring Spinner,* 2016, photograph. Courtesy of ILGWU archive.

Fig. 5. Carole Frances Lung, *Frau Fiber vs. Stoll,* 2016, video. Filmed at StrickChic, Apolda, Germany. Courtesy of ILGWU archive.

Fig. 6. Institute 4 Labor Generosity Workers & Uniforms (Frau Fiber's headquarters and experimental factory, 322 Elm Avenue, Long Beach, California) on the anniversary of the Triangle Shirtwaist Factory fire, March 25, 2016. Courtesy of ILGWU archive.

Fig. 7. Frau Fiber at the Institute 4 Labor Generosity Workers & Uniforms in the annual production of 146 commemorative blouses honoring those who died in the Triangle Shirtwaist Factory fire, March 25, 2016. Courtesy of ILGWU archive.

the narrative to offer a feminist critique—in this case, of the industry of bondage pornography. Steyerl, even more than Rosler, unsettles distinctions between documentary and fiction. Her focus provides a lens for a broad-ranging interrogation of what constitutes freedom and bondage, including the drone of sweatshop labor (this time to the tune of Donna Summer's 1983 "She Works Hard for the Money").

The pace of Rosler's and Steyerl's videos is deliberate, making certain demands on a viewer's attention span, but interspersed with dance music and varied visual evidence. Julia Brown's *Live feed; printer-error identification station and operator at an Italian luxury-silk textile factory; Or, before "Leaving the Factory," the meditative disposition's instinct for privacy* (fig. 3) asks the viewer to stand just behind a worker and experience her labor, which appears in an unending loop. The screen glows with scrolling silk as the woman checks for machine-made mistakes. Brown foregrounds beauty and drudgery, and buries, for a researcher to uncover, a critique of the entanglement of the garment industry with art patronage.

Carole Frances Lung (Frau Fiber's archivist and biographer) and Wang Bing take slowness to even more extreme lengths in their durational videos. Lung's four-and-a-half-hour *Frau Fiber vs. the Circular Knitting Machine* is the first in a series of real-time films in which her avatar competes by hand against means of industrial production. In addition to taking on a sock factory, Frau Fiber has faced off with a ring spinner (fig. 4) and a flatbed knitting machine (fig. 5). Of the artists in *Fast Fashion / Slow Art*, Lung is the most wholly concentrated on garment industry critique and activism. Her studio and headquarters, the Institute 4 Labor Generosity Workers & Uniforms (ILGWU), pays homage to the International Ladies' Garment Workers' Union, which Rosler also thanks in the credits of her video. In addition to starring in time-based media, Frau Fiber conducts workshops and performances that draw heavily on historical research. The anniversary of the Triangle Shirtwaist Factory fire, wherein 146 garment workers died in 1911, is the occasion for an annual event (figs. 6–7).

In *Frau Fiber vs. the Circular Knitting Machine*, Lung approaches her activism with deadpan humor. Wang, by contrast, is a filmmaker who is refashioning cinema verité for the twenty-first century.

3

4

6

5

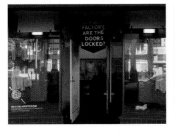

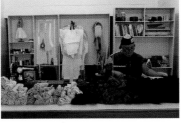

7

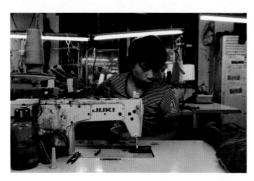

Fig. 8. Wang Bing,
15 Hours (Shi Wu Xiao Shi), 2017, 16:9 film, color, sound in Chinese Mandarin and dialect with English subtitles; in two parts, 7 hours, 55 minutes each. Edition of 6 + 2 AP, courtesy of the artist and Galerie Chantal Crousel, Paris.

Fig. 9. Rosemarie Trockel, installation view of *Yvonne* (1997, video) at the Galerie für Zeitgenössische Kunst Leipzig. © 2019 Artists Rights Society (ARS), New York / VG Bild-Kunst, Bonn; courtesy of GfZK Leipzig.

15 Hours (Shi Wu Xiao Shi) (fig. 8), his longest film to date, records a day in the life of a garment-processing facility in Huzhou, China—the length of the film determined by the length of the work day.[4] Wang's "cinema of labor," as Elena Pollacchi has described his oeuvre, relies on vast footage made possible (on his limited budget) by digital technology. His films are notable for how intimately they convey people's everyday lives and the effects of China's rapid economic growth.[5] Although their work is stylistically different, both Wang and Rosler deploy documentary footage to explore the particular challenges people face in their own time. *Martha Rosler Reads "Vogue"* comments, for example, on the problem of contracting (the scandal regarding where Nancy Reagan's high-fashion clothes were actually made). Wang's attention to garment workers—in *15 Hours* and also in another film, *Bitter Money* (2016), which begins by tracking the journey of two teenage cousins from

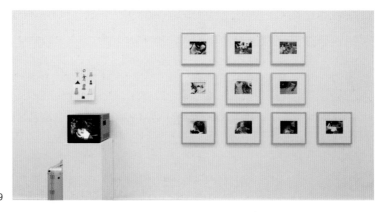

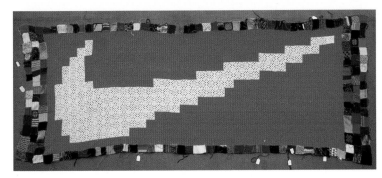

Fig. 10. Cat Mazza, *Nike Blanket Petition*, 2003–8, crochet and knit, natural and synthetic yarns, and web media, 15 × 5 ½ feet. Image courtesy of the artist.

rural China to Huzhou—provides a granular view of the widespread phenomenon of migrant labor in contemporary China.

The videos by Rosemarie Trockel, Cat Mazza, Senga Nengudi, and Martin de Thurah share concerns with the films discussed above, including an interest in the performative and for relations between hand-making and industrial production. However, they take a different tack. Trockel's *Yvonne* features friends of all ages cavorting in the artist's eccentric woolen creations. The only other work in the show from the twentieth century, like Rosler's video, *Yvonne* conjures a nexus of ideas that plays out in myriad ways in the twenty-first. Sometimes exhibited as part of an installation that includes photogravures of video stills and a suitcase containing items worn in the video (fig. 9), *Yvonne* asks to be understood in the context of Trockel's career. Famously, for example, she interrogated the privileged status of painting by having corporate logos and other impersonal motifs converted into patterns for machines to knit—and exhibiting these in lieu of oils on canvas. Highly personalized adornments were handmade for *Yvonne*'s cast. Together, the various modes of production suggest an investigation of the relationship between handicraft, the work of art, and late capitalist technologies.

As an artist who consistently works with textiles, often with an activist agenda, Mazza is closest to Lung in her overall practice. Perhaps most famously, she organized makers from around the world to contribute to her *Nike Blanket Petition*, which appealed to the corporation for fair labor conditions with crocheted squares in lieu of signatures (fig. 10). Her scrutiny of the intersection between technology and textiles, however, puts her into a direct lineage with Trockel. For *Fast Fashion / Slow Art*,

Fig. 12. T-shirts produced by National Public Radio's *Planet Money Makes a T-Shirt,* 2013. Collection of Pietra Rivoli, photo by Blaine Dunn.

Fig. 13. *Aftenposten, Sweatshop—Deadly Fashion,* 2014, five-episode web series. Courtesy *Aftenposten,* photography by Pål Karlsen.

Mazza has conceived a video installation, *Electroknit Dymaxion,* that will combine grid-based designs drawn from multiple sources, including the Textile Museum's collection (Plates 10–11). After converting motifs into knitting patterns with the help of an open-source program she developed in 2004 with the help of programmer Eric St. Onge, Mazza will have her knitting machines use the patterns to create "paintings," some of which she will animate and project onto a polyhedron inspired by Buckminster Fuller's Dymaxion map. If Trockel targets the elitism and sexism of the art world through outsourcing and hand-making, Mazza aims to connect communities through an open-source web application that generates patterns for hand-making.

Nengudi's *The Threader* (Plate 12), like *Yvonne,* glories in the physical relationship between skein and human body. As a portrait of one of the last highly skilled textile workers employed in a New York City factory, Nengudi's film alludes to the dwindling number of such jobs in the United States. The Scalamandré factory, founded in 1929 in Queens, New York, supplies luxury decorative textiles to the White House, among others. In 2004, for the sake of cutting costs, it moved most of its production to a technologically up-to-date facility in North Carolina. Only a few artisans remained, in rented quarters, including Amir Baig, the star of *The Threader.* While the film is elegiac in mood, Nengudi's focus is on the beauty of such work and the way labor can be akin to dance.[6]

In Martin de Thurah's short, staged film, *Stories* (fig. 11), a girl walks through Berlin peeling white T-shirts off her body like some variation of a clown car, discarding them with insouciance. The impression of a camera simply recording without judgment creates a surreal dissonance between real and unreal. That the T-shirt is both indispensable and utterly disposable in this dreamlike sequence speaks pointedly to a theme of so much of the work in *Fast Fashion / Slow Art*: the invisibility of the human cost of producing fast fashion.

A final cluster of videos includes more mainstream fare. National Public Radio (NPR)'s *Planet Money Makes a T-Shirt,* an interactive website combining text with video, documents the process entailed in making a T-shirt, from growing cotton in Texas to sewing in Bangladesh to transporting the shirts back to NPR listeners (fig. 12). *Sweatshop—Deadly Fashion* (fig. 13), a reality show produced by *Aftenposten,* Norway's largest

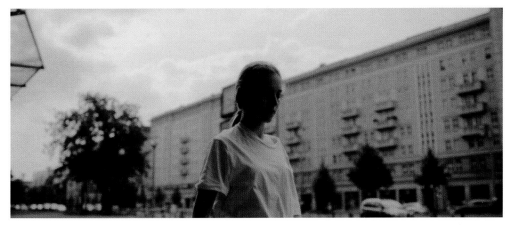

11

12

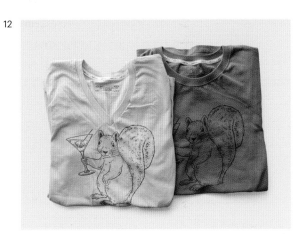

13

newspaper, took three young fashion bloggers to Cambodia to see what working conditions are like there, turning two of them into activists. In both of these, the imagined viewer is unambiguously the (relatively well-off) consumer and the goal is consciousness-raising. Also worth noting in this context is comedian John Oliver's meticulously researched 2015 segment on fast fashion for *Last Week Tonight*, which hilariously and incisively exposes the human price of dirt-cheap fashion and how previous exposés have made no difference.[7]

Whereas most of the videos focus on production, the two guest essays in this catalogue address what happens after clothing is made: Thuy Linh Nguyen Tu analyzes the labor of distribution, and Kirsty Robertson the environmental impact of discarded textiles. Tu and Robertson point to new directions in scholarship, and in their sensitivity to the cultural connotations of their studies, offer their own play on the documentary form.

The work by these artists, filmmakers, and scholars cannot solve all the intractable problems plaguing the textile industry. But they can be sites to address these issues creatively and from new angles. When we (read: consumers) think of mass production, we sometimes forget that there are still people—often with specialized skills—involved. Conversely, when we (read: conscientious consumers) call for local consumption over global, we may not take into account the complex calculus required to evaluate the political and environmental pros and cons. Taken together, the works of *Fast Fashion / Slow Art* ask viewers to pay attention to the people and issues concerned in the fabrics—quite literally—of our lives.

1 For a helpful overview, see Elizabeth Cline, *Overdressed: The Shockingly High Cost of Cheap Fashion* (New York: Penguin, 2012).

2 Charles Baudelaire, "The Painter of Modern Life" (1863), in *The Painter of Modern Life and Other Essays*, trans. Jonathan Mayne (New York: Da Kapo Press, 1964), 12.

3 Cline, *Overdressed*, 41; Harry Moser and Sandy Montalbano, "Why Made-in-USA Fashion Is Turning Heads," *Industry Week*, January 18, 2018, https://www.industryweek.com/economy/why-made-usa-fashion-turning-heads.

4 Britta Bürger, "Der radikale Blick des Wang Bing," *Deutschlandfunk Kultur*, July 15, 2017, https://www.deutschlandfunkkultur.de/independent-film-in-china-der-radikale-blick-des-wang-bing.2168.de.html?dram:article_id=391151.

5 Elena Pollacchi, "Wang Bing's Cinema: Shared Spaces of Labor," *WorkingUSA: The Journal of Labor and Society* 17, no. 1 (March 2014): 31–43.

6 Julie V. Iovine, "A Song of the Loom Is Silenced," *New York Times*, March 25, 2004.

7 "Fashion: Last Week Tonight with John Oliver (HBO)," April 26, 2015, https://youtu.be/VdLf4fihP78.

The Art of Warehousing

Thuy Linh Nguyen Tu On the edges of Sunset Park, Brooklyn, a neighborhood named for its elevated park offering beautiful views of the sun setting on Manhattan, sits the Brooklyn Army Terminal (fig. 1). Formerly known as the Brooklyn Army Base, this four-hundred-million-square-foot complex was the largest military supply base in the United States up until World War II. Since 1919, countless troops, tons of supplies, and thousands of workers have moved through here. But with the exception of a few snapshots of Elvis Presley dispatching to Germany from the port in 1958, few New Yorkers have set eyes on this place.[1] Standing on the docks of this Brooklyn waterfront, one gets the sense that it was made to see—out onto Manhattan and the world—but not to be seen.

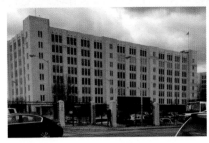

PEOPLE LIKE ALBERT WONG KNOW IT WELL, THOUGH. Every day he walks from the R train and crosses under the expressway to get to the Terminal's East Building. On the fifth floor of this now defunct base, the fashion label Lafayette 148 has taken over one hundred thousand square feet of space and turned it into their distribution center. Known affectionately as Albert's warehouse, the facility stores and sends clothes made in Shantou, China, to over one hundred retailers and thousands of online and catalogue customers worldwide. Here, workers unload shipments from Shantou twice a day and iron, sort, tag, stock, pick, pack, and reship clothes so that they can arrive at their final destination as early as the next day.

Fig. 1. Brooklyn Army Terminal, 2018, photograph by author.

City officials have praised firms like Lafayette 148 for transforming this old base from a military space to a commercial one, but in many ways the company is simply replicating the building's former purpose.[2] The Terminal was built by the army to store and move things. Lafayette 148, among many other commercial businesses, set up there precisely because their livelihood depends on their ability to get things from makers to buyers. Few institutions understood this logistics of circulation better than the military. It built airports, shipyards, railroads, highways, warehouses, and bunkers to send people and supplies across the globe. It is from this "military art" that, according to the geographer Deborah Cohen, much contemporary global trade has emerged.[3]

If storing and moving things is an art, what does this new art of warehousing entail? According to Albert, hailed by Lafayette 148 as "Employee #1," both because he was the first hired and because his position is considered of the highest importance, this is one of the hardest jobs in fashion. "In this business," he explains, "if you're even half a day late with an order,

retailers will send it back or they will charge you enormous fees. Making clothes is easy; we figured out how to do it. It's getting them delivered that's the real headache."[4]

Despite the many awe-inspiring stories about how corporations like Amazon can zip things around the globe, goods do not move seamlessly: they get stuck in ports; sit in storage; are lost, stolen, destroyed. Making things move requires a tremendous amount of time, labor, energy, and imagination. It requires perhaps most of all the type of discipline that recalls this art's military origin.

Much of this work, like the work of manufacturing, is invisible, purposely hidden or happily ignored. But if we focus our attention here for even a moment, we would see that the warehouse is in fact the beating heart of the global fashion industry—the mechanism moving its blood and keeping it alive. What kind of work goes on here? And what does fashion look like when viewed from behind the walls of these built-not-to-be-seen warehouses, where clothes are neither made nor consumed, but entombed, waiting to be animated as objects of beauty and luxury?

THE STUFF OF FASHION

The freight elevators are loud and the irons can hiss. But otherwise, the warehouse is quiet. The staff work quickly and silently. There are few windows, but the ceilings are high, giving the feeling of airiness. Albert appreciates its height, though less for the atmospherics than for its capacity to accommodate ever-higher shelves and racks. "More racks, more clothes," he reminds me.

There is always a faint smell of rice in the air. In a small corner of the massive space, there is a makeshift kitchen with a large rice cooker. Rice is provided every day to the entirely Chinese staff. "The smell reminds me of home," I hear Xian, a picker, say.[5] Xian's job is to pull clothing from the racks and deliver them to the packaging area. A scanner now tells her exactly where to find them, but before bar codes arrived, she searched for them herself, thumbing through each piece to find the right one. In a typical day, she walks about five miles, back and forth, up and down the aisles, arms draped in dresses.

Xian is short and slight, but she moves very quickly. There is no explicit quota to fill and no time limit on each order, but Xian knows

speed is key. Her legs oblige; it's the clothes that are less accommodating. Different sizes look the same. Color variations are not always clear. Sweaters arrive folded and individually wrapped in plastic, which easily slips when stacked. Albert has manufactured shelves that tilt ever-so-slightly upward in order to contain these slippery piles. But the picker must approach it carefully. Gravity is relentless.

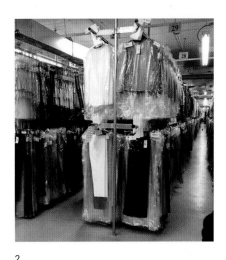

2

Fig. 2. Clothing racks at Lafayette 148, 2018, photograph by author.

"There is something eerie about a museum of costume," wrote the historian Elizabeth Wilson. The "deserted galleries seem haunted," and the "living observer moves, with a sense of mounting panic, through the world of the dead."[6] There is a similar stillness in the halls of the warehouse, where clothing hangs disembodied, existing without form and purpose (fig. 2). These are clothes that have yet to find bodies. They are not enlivened, or in Peter Stallybrass's words, "rematerialized" as "objects that are touched, and loved, and worn."[7] It is not exactly the world of the dead, but this way-stop between making and meaning-making does feel eerie.

This is not just because the clothes are disembodied, but because they exist mainly as mere stuff. Though workers see and touch each garment in this place, they feel most acutely only their material makeup. Like the sewers and patternmakers who understand the properties of clothing, how fabric folds and falls, warehouse workers hone in on the stuff of fashion—on the qualities that make it difficult or easy to wrinkle, tear, warp, and even rot. Their job is to preserve these goods. Preservation is an art form that requires the most intimate knowledge of an object's composition.

Recently, for instance, Lafayette 148 added shoes to its collections. Where the company's designers saw a sandal, Albert and his team saw the remains of an animal. Flesh. Skin. Albert carved out a dark, windowless corner of the warehouse for these shoes, closed it off with plastic strips for a doorway, and pumped up the air conditioner. He created, in other words, a meat locker—storage befitting its contents.

Preservationists understand that even the most durable goods can deteriorate. They know that the touch of a hand, with its invisible

oils, or the exposure to air can, over time, wear down a thread. But for the warehouse worker, the threat of ruination is always imminent. They fight against the most pernicious kind of erosion—the erosion of economic value.

SPEED AND SPOILAGE

"The customer cannot wait," Albert says with half a smile after I remark on how fast Xian moves. He is kidding, but he is also right. In recent years, fashion has sped up dramatically, both at the higher end, where luxury consumers can "see now, buy now" their favorite runway looks, and at the lower end, where shoppers can browse newly stocked shelves every time they arrive at the mall.

We typically use the term "fast fashion" to describe mass-market clothing, quickly and cheaply made, but in a sense, all fashion is now "fast" fashion. All fashion depends on the quality of speed. It is an essential element of their value. Lafayette 148's clothes sell at higher-end retail outlets likes Saks Fifth Avenue and Nordstrom; the quality of the fabrics—silk, cotton, leather, shearling—reflected in their higher costs. But none of this would be worth anything, Albert tells me, if it does not arrive at the stores on time. "If we're late, they might not accept it at all. We can't sell them. They're ruined."

When Albert says that the clothes are "ruined," he does not mean, of course, that they can no longer be used, only that they have no or decreased exchange value. But it is this kind of deterioration, this loss of economic value, that most preoccupies the entire global fashion industry. At a time when we are glutted with clothes, thanks to the increased speed of production, retailers have a very small window to sell clothes at full price. After a few weeks, sometimes days, they are discounted or removed from the shelves altogether. Retailers struggle with how to rid themselves of billions of dollars' worth of unsold clothes, which, if discounted, can damage their brand, and if destroyed, costs time, labor, and money. There is a reason we use food terms like "leftovers" to describe overstocked clothing sold at discounted stores. Like those organic substances, clothes too can spoil.

Over the last decade, Albert has done everything he can to ensure that Lafayette 148's clothes do not spoil, that they move at maximum speed.

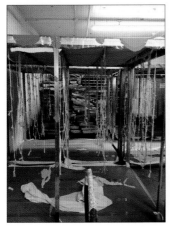 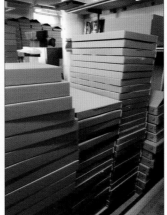 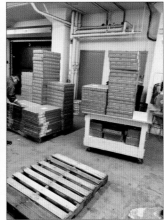

3 4 5

The company now flies their clothes across the Pacific, rather than using the far slower shipping method. They maintain their own trucks to pick up deliveries from the airport. They have invented new shipping crates: metal boxes that are built in Shantou and discarded in Brooklyn. Each box allows three thousand pieces of clothing to hang without wrinkling. Several crates arrive each morning and evening (fig. 3).

Unload, iron, sort, tag, stock, pick, pack, and reship. Each task has a dedicated location, each worker focused and disciplined. "I'm always watching the clock," Albert once told me. But I can see that everyone else does too. I see the crush of time on them. The operation requires nearly forty employees working six days a week, but by most standards this is a small outfit. Amazon's warehouses employ thousands. In fact, as more and more stores shutter and move online, laid-off retail employees are most often turning to employment in warehouses, moving things around the clock that they neither made, bought, nor sold.[8]

The packers, located near the delivery areas where the crates from Shantou also arrive, line each outgoing box with a thin sheet of paper emblazoned with the brand's name, neatly fold each garment, seal the package, and stack the boxes in piles reaching the ceiling (figs. 4–5). They repeat this dozens of times per hour. When the delivery trucks finally arrive, each packer is surrounded by so many boxes that he or she appears to be standing in a cardboard tomb.

Fig. 3. Empty shipping crates, Lafayette 148, 2018, photograph by author.

Figs. 4–5. Mailing boxes, Lafayette 148, 2018, photographs by author.

UNDURABLES

For all their speed, precision, ingenuity, and discipline, Albert and his team are fighting a losing battle—not theirs, but ours. Seen from the vantage point of the warehouse, clothes reveal themselves to be undurable, fragile goods whose use and values are always in flux and under threat. This is not because these objects are themselves delicate. It is because our desire for fast fashion, which is to say fashion writ large, has created such conditions of precariousness—for workers, the environment, and for the very objects of our desire.

When it comes to clothing, most Americans violate what the philosopher John Locke called the "spoilage limitation," the principle that a person may not claim ownership of so many things that some spoil before he is able to use them. Locke was referring to natural resources, not durables like money, the hoarding of which he enthusiastically endorsed. But what if the goods we consider to be enduring prove themselves to be not so hardy after all? Would recognizing their lack of durability force us to rethink our accumulation?

In this time of relative sartorial abundance, we attribute little value to the usefulness of our clothes; we discard them even when they can still be worn, and accumulate them even when we have no need. We are limited primarily only by what we can spend. What if we accept that clothes are not fixed, stable objects? What if we saw the work it takes to not only make them, but preserve them? What if we saw in their deterioration our own vulnerability—to the discipline of the market, to the demands of time. Would we try to stop their ruination—and our own?

1 See Brooklyn Army Terminal, accessed October 8, 2018, https://www.bklynarmyterminal.com.

2 Perhaps the army even had foresight about the base's eventual use. After all, it chose Cass Gilbert to design the Brooklyn Army Terminal, the architect of the famed Woolworth Building, dubbed by the *New York Times* as "the Cathedral of Commerce" at its completion.

3 Deborah Cowen, *The Deadly Life of Logistics: Mapping Violence in Global Trade* (Minneapolis: University of Minnesota Press, 2014).

4 Albert Wong (warehouse manager, Lafayette 148), interview with the author, March 12, 2015. All quotations and observations are drawn from multiple visits to the warehouse from 2015 to 2018. During this period, I spoke with Albert and several other workers on multiple occasions; I recorded those conversations on March 12, 2015; March 8, 2016; and March 6, 2018. I have chosen not to change Albert Wong's name because his identity as the manager of the warehouse is public information, but to create pseudonyms for the other workers, whose identities are not public.

5 Xian is a pseudonym.

6 Elizabeth Wilson, *Adorned in Dreams: Fashion and Modernity* (1985; rev. ed., New Brunswick: Rutgers University Press, 2003), 1.

7 Peter Stallybrass, "Marx's Coat," in *Border Fetishisms: Material Objects in Unstable Spaces*, ed. Patricia Spyer (New York: Routledge, 1998), 183–207.

8 Spencer Soper, "Amazon Is a Lifeline for Retail Workers (If They Live in the Right City)," *Bloomberg News*, September 20, 2017, https://www.bloomberg.com/news/articles/2017-09-20/amazon-is-a-lifeline-for-retail-workers-if-they-live-in-the-right-city.

The Afterlife of Clothing

Kirsty Robertson

At the outset of Alexander Mackendrick's Ealing Studios film *The Man in the White Suit* (1951, fig. 1), textile millowner Alan Birnley tells the story of inventor Sidney Stratton. Birnley alludes to events in the recent past that precipitated a crisis that was "fortunately" averted. The film is about that crisis, a near riot triggered by Stratton's invention—an indestructible textile that repels dirt and never needs to be washed, mended, or replaced. The beginning of the film follows Stratton in his quest to invent the textile, a process that is marked by failure, explosions, his being fired from one factory and surreptitiously working at another, and finally, against all odds, success.

FOR A MOMENT, STRATTON IS IN THE LIMELIGHT, his every wish acted upon as the millowner dreams of the profits that might flow from the indestructible thread. A prototype is made—the white suit of the title—a glowing and numinous object worn by Stratton (fig. 2) as he tries to evade both the union workers and factory bosses who have turned on him, all surmising that his invention will result in the death of the textile industry, putting the workers out of work and the owners out of profits. Chaos ensues. Stratton is imprisoned in Birnley's mansion so that word of the suit will not get out. Daphne, Birnley's daughter and fiancée of the millowner in whose factory Stratton's experiments succeeded, is brought in to "help" the situation (that is, to seduce Stratton into accepting a buyout). Instead, she taps the millowners for a significant payment and helps Stratton escape out of the window using the indestructible thread.[1] In the final scenes, as Stratton is surrounded and appears about to be mobbed, the suit begins to disintegrate—the thread is not stable, and the jobs and factories, and a Fordist capitalism built on manufacture, are saved. But as Stratton walks off into an indistinct future, his head hung low, he stops, leaps in the air, and shouts, "Eureka!" Viewers are left to surmise that he has solved the puzzle that led to disintegration and his textile will live to see another day.

The Man in the White Suit was released at a moment of profound change in the textile industry, just as synthetic fibers such as nylon were transferring from the war industry to the civilian one.[2] Many innovations came down the production line, including a number of trademarked and treated fabrics that seem to have realized Stratton's failed invention.[3] Waterproof, stain-resistant, and fire-resistant clothing

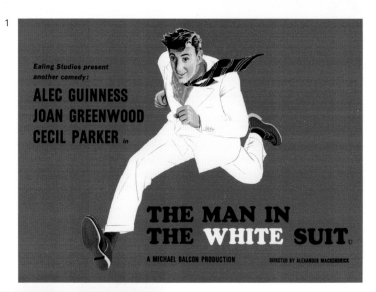

Ealing Studios present
another comedy:

ALEC GUINNESS
JOAN GREENWOOD
CECIL PARKER in

THE MAN IN
THE WHITE SUIT U

A MICHAEL BALCON PRODUCTION DIRECTED BY ALEXANDER MACKENDRICK

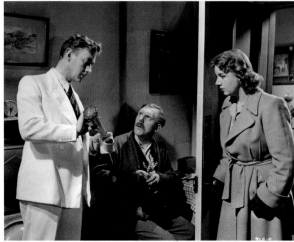

2

is now fairly standard. Such inventions, however, have not destroyed the textile industry. What neither the workers nor the factory bosses in the film foresaw was the covetousness of buyers. Durable fabrics that last long beyond the life spans of their wearers have expanded the industry exponentially as they are cheap to make, resulting in a rapid sequence of buy-and-replace that dominates current fashion cycles and adds to a growing problem of textile waste. *The Man in the White Suit* has two blind spots: first, that fashion overcomes use value (it does not

matter if the textiles are long-lasting), and second, that under a capitalist system, profits far outweigh labor and other concerns. Thus, this essay is something of an epilogue to *The Man in the White Suit*. What happens to the white suit, with its unbreakable threads, once it is no longer fashionable? Its life as a desirable object is short, but its life as a material object is long—an equation that reaps devastating environmental costs.

Amy Sargeant provides a fascinating reading of *The Man in the White Suit* by looking into the money behind Ealing Studios, specifically that of financial director Stephen Courtauld, a member of the family now best known for establishing the renowned Courtauld Gallery.[4] The Courtaulds' wealth was derived from textiles.[5] Although Stephen Courtauld did not sit on the board of directors of the family textile firm, the wealth that he invested in the studio and the film came directly from the family business, which was largely run by his brother Samuel. Sargeant argues that various characters and scenes in the film evoke the reality of the Courtaulds' textile empire.

Courtaulds Ltd. was involved not just in making fabric, but in modernizing the UK industry through the advent and production of synthetic textiles, chief among them synthetic silk.[6] The Courtauld business was absolutely au courant. As Sargeant writes, "Stratton may have failed, in *The Man in the White Suit*, to produce a miracle fibre but he was not alone in trying."[7] As Sargeant points out, the film was made in the same year that Courtauld's US rival DuPont introduced Dacron, a synthetic fiber that promised wrinkle-free clothing and the end of ironing.

Synthetic textiles were the future. As Daphne says to Stratton: "[You've] won the battle against shabbiness and dirt."[8] But the film is careful to acknowledge the potential pitfalls (even if it understands these only in terms of labor), noting that union advances will be for naught if there are no textiles to be made. Further, in a poignant scene, Stratton runs from the crowd and bumps into his elderly landlady, who asks him what she will do without the extra laundry she does to bring in a few coins. All along the chain (and not the chain of molecules with which he is obsessed), Stratton's indestructible textile will make life difficult for workers. In point of fact, the workers were correct—jobs in the UK *were* lost, although it was to outsourcing and the globalization of the textile industry. Indeed, after growing to become the world's largest artificial

Fig. 1. S. John Woods and A. R. Thompson, *The Man in the White Suit*, 1951, movie poster. Image courtesy of STUDIOCANAL Films Ltd.

Fig. 2. Stratton demonstrates the strength of the white suit's fabric to workers from the textile mill. Still from *The Man in the White Suit*, 1951. Image courtesy of STUDIOCANAL Films Ltd.

fiber production company, from the 1980s Courtaulds Ltd. closed many of its UK plants, outsourcing its manufacturing to Asia. In the 1990s, the original company was broken up and eventually sold in the early 2000s.[9]

Thus, the company providing the family money and fodder for the film is no longer. But what about that white suit? At the end of the movie, Stratton's suit disintegrates. The crowd, laughing now that they have been saved, pull great wads of fabric apart, leaving Stratton standing alone in his cotton underwear, the ground littered with tufts of a fabric that had seemed indestructible. Everyone, including Stratton, walks away. But I am left thinking about those clumps of fabric, which may have been swept from the studio into the rubbish, and then into a landfill, where they sit quietly to this day. The white suit was not indestructible in the way that Daphne envisaged—there is no doubt that those tufts are currently shabby and dirty—but they are enduring nonetheless.

A 2018 study showed that "sixty-three percent of textile fibres are derived from petrochemicals whose production and fate give rise to considerable carbon dioxide (CO_2) emissions."[10] At each stage of their production and use, textiles (including those derived from natural fibers such as cotton and those derived from petrochemicals such as nylon) have intensive environmental effects including, but not limited to, water depletion and toxic pollution from pesticides in the growth and production of cotton, land stripping and destruction in the extraction of petrochemicals, toxic emissions from wet treatment processes (such as dyeing and printing), fossil fuel energy use in the spinning of yarns and knitting of fabrics, and emissions of carbon dioxide and particulates (also in these processes) such that "impact per garment use in a western country… must be reduced by 30–100% by 2050 if the industry is to be considered sustainable with regard to the planetary boundaries."[11] Simultaneously, we live in a world in which plastic polymers proliferate (there are now more than ten thousand types), although it is scarcely more than a century since the first synthetic plastic was invented.[12] Since then, the use of plastics has skyrocketed and human usage has increased from negligible in the 1940s to 260 million tons per year in 2009.[13] Though synthetic textiles represent but a percentage of these totals, the accumulation of plastics is staggering. Our environment is quite literally suffused with plastic waste and a miasma of plasticizers in the water and air. In an extremely

short time, humans have invented, used, and acclimatized to plastics so that we now breathe, eat, and drink microplastics and microfibers as a matter of course. And we most certainly wear them on our bodies, and throw them out when we're done.

According to the Environmental Protection Agency, in the United States 85 percent of textiles, many of them synthetics, end up in landfill.[14] Plastics do not biodegrade, but they do photodegrade, breaking down under light sources into ever smaller flecks of microplastics and microfibers before losing form to their toxic molecular components (often only after many thousands of years). Surely this is an outcome that Daphne and Sidney, caught up in the hope of long chain polymers, could not have imagined. In the film, Stratton's suit is envisioned as a singular, auratic garment—the only one that he will wear for the rest of his life, regardless of fashion trends.

It was not to be. Watching hundreds of people drop off textiles for recycling (upcycling into new clothing or downcycling into insulation, stuffing, or rags) at a Wearable Collections depot in New York City, David Goldsmith notes that textile recycling is often thought of as a worthy intervention that might "mitigate the damages caused by the intense appetite of the fashion beast."[15] But Goldsmith, like many others, questions whether deterring certain textiles from entering landfills has real effect against the vast production of new clothing and continued exploitation of virgin materials.[16]

Textile recycling is often perceived as a process that magically happens, when in fact it is massively complex. This is particularly true of synthetics, which cannot simply be unraveled. Without going into too much detail, textile recycling of synthetics can involve mechanical, chemical, and thermal processes. Chemical recycling involves a progression by which "polymers are depolymerized"; they are "dissembled to molecular levels [and then] monomers or oligomers are repolymerised, and polymers respun into new fibres."[17] Thermal recycling often refers to "the conversion of PET [polyethylene terephthalate] flakes, pellets or chips into fibres by melt extrusion."[18] This language has the same cadence as a monologue that Stratton gives to an increasingly rapt Daphne about his textile invention, heavy on terms such as "polymerizing amino acid residues," "long chain molecules," "ionic groups," "reactive groups at the end

3

Fig. 3. Ben Premeaux, *Repurpose: The Story of Flint Fit*, 2018, video still. This documentary still features shaved plastic from recycled bottles before it is turned into thread at Unifi, Inc. Courtesy of the filmmaker.

of the peptide chains…." But obviously the outcome is distinct: the goal of much textile recycling is to create a "circular economy," essentially to reuse material resources to create secondary, tertiary (and so on) profit streams. Thus, the recycling of PET plastics, such as water bottles into new fabrics, is seen as a winning situation in that new profits are created and some plastics are diverted from the waste stream.[19] But it has been repeatedly proven that fabrics created in this way shed millions of plastic microfibers, which have been shown to enter the food chain and may be creating impacts that we are not currently equipped to measure or respond to.[20]

Textile recycling tends to be defined in purely profit-oriented ways and roadblocks are typically seen as purely mechanical so that, for example, while it is currently difficult to separate mixed fibers (such as stretch denim containing cotton and synthetics), it is assumed that solutions will eventually be found.[21] Less frequently are the *problems* with recycling discussed: for example, "climate impact can increase if recycling processes are powered by fossil energy."[22] Jesse R. Catlin and Yitong Wang have shown that access to recycling can in fact result in increased resource consumption.[23] Finally, recycling simply does not address the incredibly slow rate of decay of synthetic fibers, and occasionally exacerbates these problems. In short, if the white suit had existed today, it could be chemically and thermally recycled into a new garment, but the processes by which this would take place a) could be more energy intensive than the

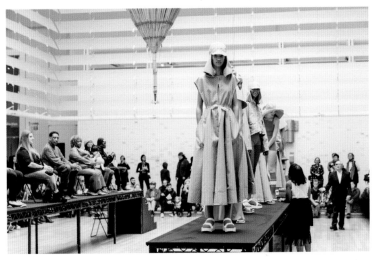

original making of the suit and b) could result in fabric that is actually less stable—that may disintegrate just as Stratton's suit does.

To further explore these issues, I turn briefly to *Flint Fit*, artist Mel Chin's recent project in Flint, Michigan. Chin's project focuses on two interconnected problems: first, the lack of clean water in Flint, Michigan, which has brought with it a proliferating number of plastic bottles used by those who cannot drink contaminated municipal water, and second, the loss of textile manufacturing jobs (and manufacturing jobs in general) in a second city, Greensboro, North Carolina. The project collects plastic water bottles used in Flint and breaks them down, melt spinning them into threads that are then woven into clothing. *Flint Fit* has transformed ninety thousand used bottles collected by Flint residents into a "hopeful possibility," and a boutique collection created by fashion designer Tracy Reese (figs. 3–4).²⁴

Though *Flint Fit* is quite different from *The Man in the White Suit*, there are distinct echoes of the labor issues invoked in the earlier film, and of the fraught utopian possibilities offered by textiles. Chin's project diverts plastic bottles from the landfill, provides jobs, and celebrates the couture of a designer who was born and raised in Detroit, Michigan. The project creates a line of clothing made not just from polymer chains, but from polymer chains twice removed from the original fossil fuel source. But the fabrics made as part of *Flint Fit* have impact far beyond

Fig. 4. *Flint Fit* collection fashion show, April 8, 2018. Models wear *Flint Fit* prototype garments and Flint residents who participated in organizing, bottle collection, and fashion production are also onstage. *Flint Fit* is a project by Mel Chin, commissioned by Queens Museum and No Longer Empty; the *Flint Fit* collection was designed by Tracy Reese. Image courtesy Queens Museum, photo by Kuo-Heng Huang.

the bounds of the project. Ultimately, fabrics made from melt spinning PET are the twenty-first-century equivalent of Stratton's disintegrating and unstable suit.

The Man in the White Suit and Flint Fit offer layered ways of understanding both the promises and shortcomings of synthetic textiles. Each centers a social issue—labor relations in the former, the contamination of Flint's water in the latter—and in each, synthetic textiles are used as pseudo-utopian solutions that must, on closer examination, be questioned. While The Man in the White Suit is a comedy and Flint Fit a critical art project, both reinforce an understanding of synthetic textiles as something that exist only in the present moment. Instead, the afterlives of the white suit and the wardrobe created for Flint Fit last centuries, where remnants and fibers will remain and scatter into environments far removed from the original place of their production, suggesting a timescale and geographic profligacy completely disproportionate to their creation, and impactful far beyond their initial imaginings.

1 Further, see Mark Duguid, "That Ealing moment: The Man in the White Suit," British Film Institute, updated April 4, 2014, https://www.bfi.org.uk/news-opinion/bfi-news/ealing-moment-man-white-suit.

2 Matthew T. Huber, *Lifeblood: Oil, Freedom, and the Forces of Capital* (Minneapolis: University of Minnesota Press, 2013), 72–94.

3 Kirsty Robertson, "Oil Futures/ Petrotextiles," in *Petrocultures*, ed. Sheena Wilson and Imre Szeman (Montreal and Kingston: McGill-Queen's University Press, 2017), 242–63.

4 It was Stephen Courtauld's older brother Samuel who helped to establish the Courtauld Institute and bequeathed to it his house and art collection.

5 Amy Sargeant, "*The Man in the White Suit*: New Textiles and Social Fabric," *Visual Culture in Britain* 9, no. 1 (2008): 30.

6 Sargeant, 30.

7 Sargeant, 40.

8 Sargeant, 40.

9 Chris Godsmark, "Courtaulds Textiles sells last spinning mills," *Independent*, December 3, 1996, https://www.independent.co.uk/news/business/courtaulds-textiles-sells-last-spinning-mills-1312788.html; Harry Wallop, "Hong Kong firm buys Courtaulds," *Telegraph*, May 10, 2006, https://www.telegraph.co.uk/finance/2938442/Hong-Kong-firm-buys-Courtaulds.html.

10 Gustav Sandin and Greg Peters, "Environmental Impact of Textile Reuse and Recycling: A Review," *Journal of Cleaner Production* 184 (May 20, 2018): 354.

11 Sandin and Peters, 354. This article is a review paper of forty-one other studies, a summary of which led to these claims by the authors.

12 Jennifer Gabrys, Gay Hawkins, and Mike Michael, "Introduction: From Materiality to Plasticity," in *Accumulation: The Material Politics of Plastic* (New York and London: Routledge, 2013), 2.

13 Gabrys, Hawkins, and Michael, 3.

14 David Goldsmith, "The Worn, The Torn, The Wearable: Textile Recycling in Union Square," *Nordic Textile Journal* 1 (2012): 19.

15 Goldsmith, 17.

16 Goldsmith, 18.

17 Sandin and Peters, "Environmental Impact of Textile Reuse and Recycling," 354.

18 Sandin and Peters, 354.

19 Sandin and Peters, 354.

20 Melissa Suran, "A Planet Too Rich in Fibre," *Science and Society/EMBO Reports* (July 26, 2018): 1–4.

21 Sandin and Peters, "Environmental Impact of Textile Reuse and Recycling," 355.

22 Sandin and Peters, 362.

23 Jesse R. Catlin and Yitong Wang, "Recycling Gone Bad: When the Option to Recycle Increases Resource Consumption," *Journal of Consumer Psychology* 23, no. 1 (2013): 122–27.

24 *Flint Fit*, accessed October 8, 2018, http://flint-fit.com/.

Julia Brown
(b. 1978, Ann Arbor, MI; lives and works
in Washington, DC)

*Live feed; printer-error identification
station and operator at an Italian
luxury-silk textile factory; Or, before
"Leaving The Factory," the meditative
disposition's instinct for privacy,* 2010
HD color video, sound, 2:49 minute loop
Courtesy of the artist

BROWN

The viewer watches over the shoulder of a uniformed factory worker as she searches for machine-printing errors in a luxury silk textile pattern. As the video plays in an unending loop, the worker stands in front of a large machine that feeds the bolt of fabric from one roll to another roll. Hers is one of the few remaining human interventions in a formerly artisanal and physically demanding process. The title references the 1895 Lumière film *Leaving the Factory* that helped visualize the worker as part of a collective, and a phrase by poet Louise Glück. Here the worker stands alone, and her body language expresses discomfort under the gaze of the camera and the viewer.

Shot during a shift at the Ratti S.p.A. factory in Guanzate, Italy, the video displaces the visual work of the factory operator—whose labor creates capital for the Fondazione Antonio Ratti, a contemporary patron of the arts—into the gallery.

Julia Brown

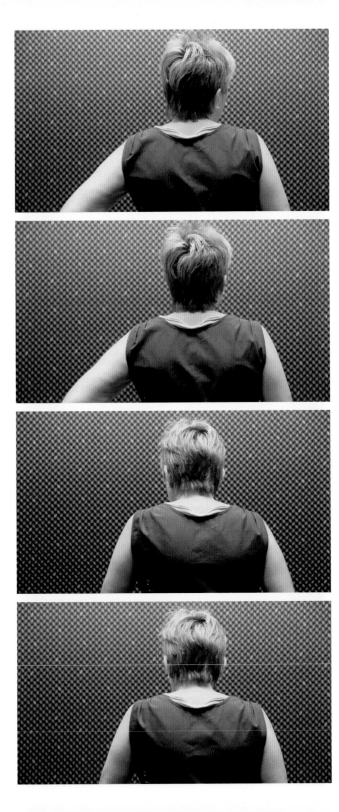

Martin de Thurah
(b. 1974, Copenhagen; lives in
Copenhagen, works around the world)

Stories, 2017
Video, black-and-white, sound,
2:04 minutes
Courtesy the artist and Epoch Films,
New York

DE THURAH

The independent films and videos by Martin de Thurah are characterized by their beautiful and lyrical, uncanny imagery. In *Stories*, which was shot in Berlin, the camera follows the movements of a casually dressed young woman as she begins taking off one T-shirt after another from the many layers she is apparently wearing. The film loops back to the image of an elderly gentleman she passes in the street, the same image with which it began, suggesting a haunting cycle of unexplained disposal and carelessly discarded clothing.

Stories was included in *Is Fashion Modern?*, a 2017 exhibition at the Museum of Modern Art, as an example of the white T-shirt's ubiquitousness and complex iconicity. Curatorial Assistant Michelle Millar Fisher aptly described the video as "a subtle, non-didactic reminder to consider our relationship to the wearing and discarding of clothing, as well as a dreamy, enigmatic choreography that reminds us of the many layers of the white T-shirt's history."[1]

Phyllis Rosenzweig with Arthur Foster

1 "Stories by Martin de Thurah," October 9, 2017, https://youtu.be/KDU6XhOGc3o.
See also Paola Antonelli and Michelle Millar Fisher, *Items: Is Fashion Modern?*
(New York: Museum of Modern Art, 2017), 262–64.

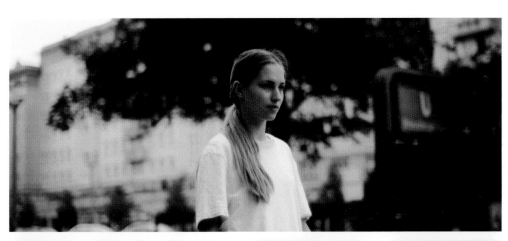
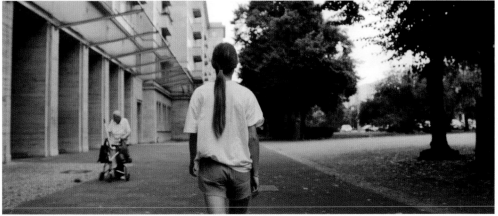

Carole Frances Lung
(b. 1966, San Francisco, CA; lives and
works in Long Beach, CA)

*Frau Fiber vs. the Circular Knitting
Machine*, 2015
Digital video, black-and-white, sound,
4 hours, 32 minutes
Courtesy of ILGWU archive

LUNG

Frau Fiber vs. the Circular Knitting Machine is a four-and-half-hour durational video shot on location on the factory floor of Wigwam Mills, Sheboygan, WI, where high-performance socks have been produced for over one hundred years. Frau Fiber is a textile superhero who advocates for transparency of the labor behind the global fast fashion supply chain. In the video Frau Fiber sits in front of a circular tube sock knitting machine, knitting a tube sock. It concludes with Frau Fiber completing her sock, and adding it to the bin of ninety-nine socks the machine has completed in the same amount of time.

This video is the first in a series inspired by the folklore of John Henry, the ultimate working-class hero. Henry was immortalized in verse and myth in the 1800s after fighting and losing a valiant battle against the steam-operated drill machine. The contest against the machine caused his untimely death, and the machine ultimately replaced the jobs of tireless railroad workers. These videos document Frau Fiber's ongoing battle with contemporary apparel manufacturing as she attempts to spin yarn and knit a tube sock and a sweater sleeve as fast as the machine.

Carole Frances Lung, associate professor of fashion, fiber, and materials, California State University, Los Angeles. Lung is Frau Fiber's archivist, biographer, and manager of the Institute 4 Labor Generosity Workers & Uniforms in downtown Long Beach, CA.

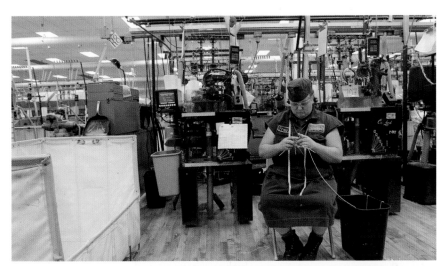

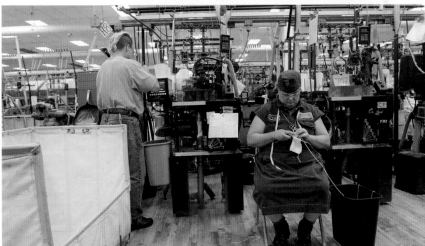

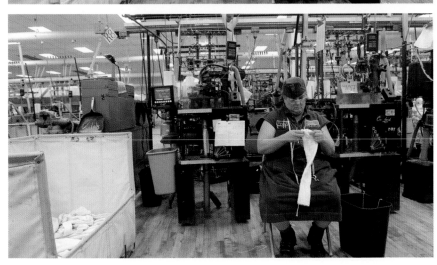

Cat Mazza
(b. 1977, Washington, DC; lives and
works in Massachusetts)

Electroknit Dymaxion, 2019
Video installation, dimensions variable
Courtesy of the artist

MAZZA

My work combines digital media with traditional needlecraft to explore the relationships between textiles, technology, and labor. The projects often investigate the history of craft cultural trends and use custom software to reexamine these histories.

Electroknit Dymaxion draws on patterns of textile motifs that are based in a grid format. The patterns emerge from grid notebooks, manuscripts, vintage craft magazines, knitting machine handbooks, and some objects sampled from the Textile Museum collection. Grid motifs are a global phenomenon, a decorative language transcribed on a graph. The wooden frame of the sculpture takes shape from a Dymaxion map to approximate the sphere of our planet. The machine-knitted scrims loosely reference the geographical origin of the pattern, and so the sculpture becomes a spatial visualization of the patterns' origins.

The project is inspired by the global use of the application knit-Pro—a craft grid generator I developed with programmer Eric St. Onge in 2004—but also a fascination with how textile patterns spread virally in a pre-digital era. *Electroknit Dymaxion* samples contemporary knitPro patterns with centuries-old motifs to create new narratives about globalization, trade, and feminized work.

Cat Mazza

Study for *Electroknit Dymaxion,* 2018, sketch for video installation in *Fast Fashion / Slow Art* exhibition. Image courtesy of the artist.

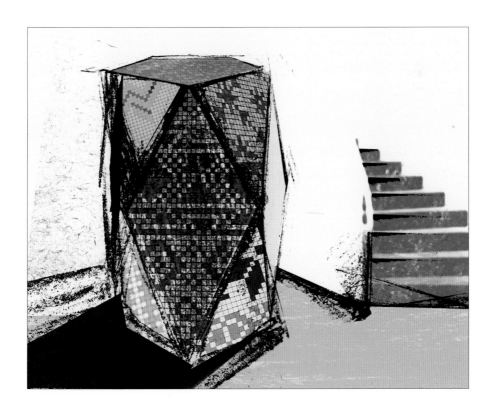

Electroknit grid patterns (studies
for *Electroknit Dymaxion*), 2018,
gouache on digital prints, 13 × 19 in.
each. Images courtesy of the artist.

Senga Nengudi
(b. 1943, Chicago; lives and works in
Colorado Springs, CO)

The Threader, 2007
Digital video, color, sound, 5:23 minutes
Courtesy of the artist

NENGUDI

Senga Nengudi is a sculptor who once said, "I always wanted to be a dancer." Nengudi is perhaps most well known for her ongoing series of stretched forms made from pantyhose that also play a collaborative role in her performances with artist Maren Hassinger.

The Threader combines Nengudi's interest in the physical properties of textiles and her engagement with dance and movement. Developed during her residency at the Fabric Workshop and Museum in Philadelphia, the video focuses on the movements of a threader, a maker of decorative silk cords, at what remains of the historic Scalamandré textile mill in Queens, New York. As Nengudi explained in an interview with Elissa Auther, "I have a side interest in men at work and the rhythms and patterns they develop as part of physical labor. I was fascinated with the dance-like patterns of moves mill-worker Amir Baig maintained to assure the skillful accuracy of his task which was making cords and tassels."[1]

The Threader addresses the conditions of skilled human labor in the face of the de-skilling of textile industries. By identifying the worker by name, Nengudi accords him dignity and recognition as an individual, a quality often denied in conditions of mass production.

Phyllis Rosenzweig with Arthur Foster

1 Oral history interview with Senga Nengudi, 2013 July 9–11, Archives of American Art, Smithsonian Institution, https://www.aaa.si.edu/collections/interviews/oral-history-interview-senga-nengudi-16131.

Installation view of *The Threader*, in *Senga Nengudi: Improvisational Gestures* at the Henry Art Gallery, July 16–October 9, 2016. *Senga Nengudi: Improvisational Gestures* was organized by the Museum of Contemporary Art Denver and the University of Colorado Colorado Springs Galleries of Contemporary Art. Image courtesy of the Museum of Contemporary Art, Denver.

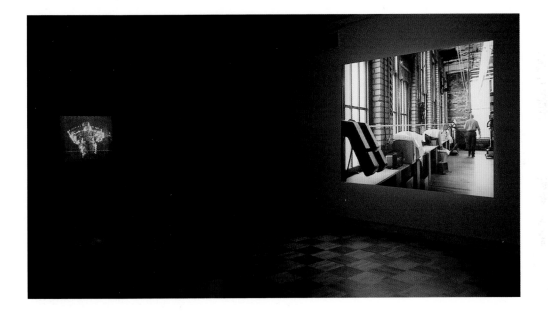

PLANET MONEY

The contentious debates around international trade, workers' rights, and globalization deserve examination not only from the conventional, different perspectives of left versus right, but also from different methods of storytelling. From the Industrial Revolution to Brexit and Donald Trump, data, outrage, history, and profiles have all provided different mechanisms to convey or to understand global economic and social forces. I wrote *The Travels of a T-shirt in the Global Economy* [on which *Planet Money Makes a T-Shirt* is based] because of my conviction that these very complex debates can be illuminated through the examination of simple products.

In *Planet Money Makes a T-Shirt*, we have a new model: participatory journalism. In this series of videos and podcasts, the reporters come as close as they can to actually making a T-shirt. In doing so they move beyond telling a story as observers to creating the story to be told. As they hold a mirror to their own creation, the effect is to reflect back and forth in a tactile way on centuries-old debates around globalization.

Pietra Rivoli, professor, McDonough School of Business, Georgetown University; author, *The Travels of a T-Shirt in the Global Economy*

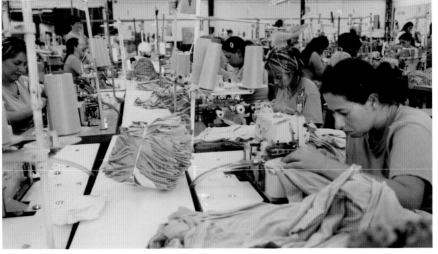

Martha Rosler
(b. Brooklyn, NY; lives and works in
Brooklyn, NY)

Martha Rosler Reads "Vogue," 1982
Video, color, sound, 25:22 minutes
Courtesy Electronic Arts Intermix (EAI),
New York

ROSLER

Produced with the New York public-access TV show Paper Tiger Television, *Martha Rosler Reads "Vogue"* is a feminist critique of media manipulation of women's images and an exposé of the fashion industry. In it we see Martha Rosler, in a red jumpsuit, seated on a chair with an issue of *Vogue* on her lap. She flips slowly backward through the magazine, that well-known arbiter of high fashion, at times caressing its pages while intoning questions about fashion and beauty. The glossy images and Rosler's deadpan narration are intercut with clips of garment workers and statistics about the low wages the workers are paid.

Rosler has always used her multidisciplinary output to address social and political concerns, including struggles for gender equality, economic injustice, and the iniquities of war. *Martha Rosler Reads "Vogue"* is a classic work in the history of video and other new media, and a pioneering exploration of the issues addressed in *Fast Fashion / Slow Art*.

Phyllis Rosenzweig with Arthur Foster

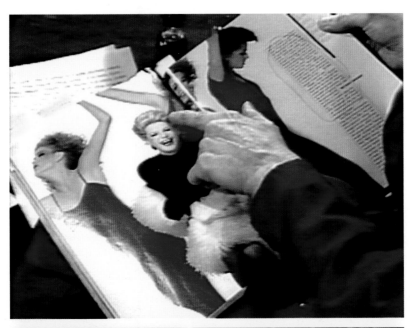

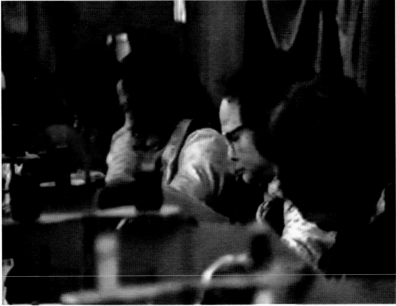

Hito Steyerl
(b. 1966, Munich; lives and works
in Berlin)

Lovely Andrea, 2007
Single-channel video, color, sound
in English, Japanese, and German
with English subtitles, 30 minutes
Courtesy of the artist and
Andrew Kreps Gallery, New York
Image CC 4.0 Steyerl
Shown in Washington, DC, only

STEYERL

In this haunting para-fictional film, Hito Steyerl inserts found footage of a music video featuring female sweatshop workers into an investigation of the sex industry. The camera follows Steyerl and her guide, bondage artist Asagi Ageha, as they search for images from a bondage photo shoot that Steyerl had posed for as a film student in need of money in Tokyo in the late 1980s. As they go from studio to studio, photographers discuss and analyze other studios' distinctive styles, while a stream of images—Ageha performing, happy sweatshop workers, Spider-Man cartoons, and images of violence and war—are collaged into the documentary-like record of the search. The video's title refers to a friend, Andrea Wolf, whose violent death Steyerl explored in an earlier film, *November* (2004). Steyerl's films and essays expose the hidden links between control over images and mechanisms of power, as represented here in the realms of war, pornography, and industrial production. She has written, "Manipulated and adulated. Reviled and revered. To participate in the image means to take part in all of this."[1]

Phyllis Rosenzweig with Arthur Foster

1 Hito Steyerl, "A Thing Like You and Me," in *The Wretched of the Screen* (Berlin: Sternberg Press, 2012), 53.

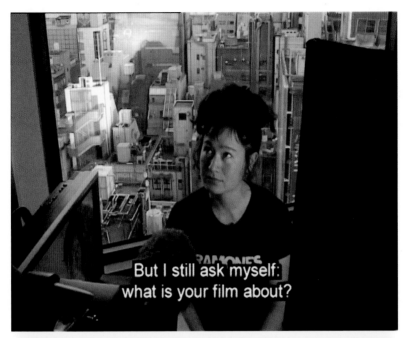

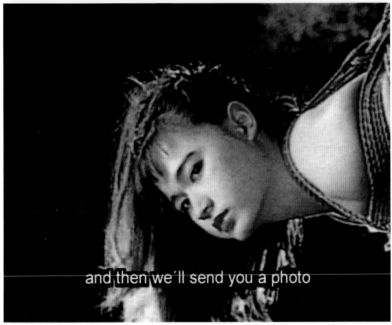

Sweatshop—Deadly Fashion, 2014
Video, five-episode web series
Courtesy of *Aftenposten,* photography
by Pål Karlsen

SWEATSHOP

The world is big and complicated. Understanding it and each other is essential but difficult. It is not easy seeing yourself, and the consequences that your way of life have on communities and individuals on the opposite side of the globe. With *Sweatshop*, we wanted to create content that would engage young Norwegian consumers and make them relate to the bigger pyramid that they reside on top of. We wanted to make the unrelatable relatable by letting them meet and work with the people that make their clothes. The show got two million views in Norway, close to three million abroad, and was awarded the Norwegian Emmy for outstanding reality show—the first award ever given to a web-based show. *Sweatshop* also ruffled feathers at H&M, one of the world's largest fashion companies (at the time one of the biggest Western investors in Cambodia, where the show was filmed), for showing that they rely heavily on cheap labor at many sewing factories to keep their profits growing. A complaint was filed and dismissed by the Norwegian Press Complaints Commission. *Sweatshop* was commissioned for a second season in 2016.

Jonas Brenna, commissioning producer, *Aftenposten*

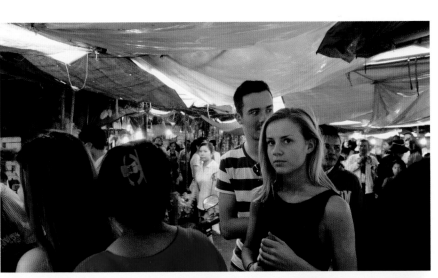

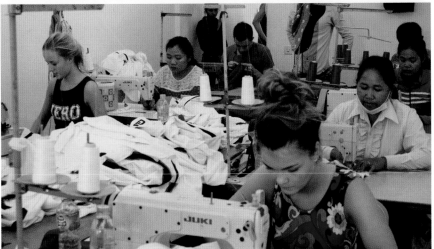

Rosemarie Trockel
(b. 1952, Schwerte, Germany; lives and
works in Cologne)

Yvonne, 1997
Video, black-and-white and color, sound,
14 minutes
Galerie für Zeitgenössische Kunst Leipzig
© 2019 Artists Rights Society (ARS), New
York / VG Bild-Kunst, Bonn; courtesy of
GfZK Leipzig

TROCKEL

References to knitting appear throughout Rosemarie Trockel's oeuvre—
which encompasses drawing, sculpture, and video—beginning with a
series of machine-knitted wool works from the early 1980s. These objects
depict abstract patterns or recognizable commercial logos and were
designed by computer and industrially produced, though ironically they
are one of a kind. The wool works were commentaries on the male- and
painting-dominated art world of the 1980s, with the use of wool as an
attributive material to so-called women's labor. Following these works, the
video *Yvonne* appeared as a wacky fairy tale with a narrative structure run
amok. In it, an ensemble of characters, including artist friends and baby
Yvonne, enter and reenter the frame in eccentric, hand-knitted outfits that
suggest exaggerated versions of the often lopsided, misshapen, and over-
size garments that many mothers, aunts, and other mostly female relatives
have lovingly made over time. Consistent with the artist's practice, motifs
and materials from *Yvonne* continue to appear in Trockel's body of work
in various guises. The video evokes a sense of domesticity and intimacy
while also serving as a reminder of the unlikelihood of clothing the world
with such laboriously produced, inventive, endearing apparel.

Phyllis Rosenzweig with Arthur Foster

Wang Bing
(b. 1967, Xi'an, Shaanxi Province, China;
lives and works in China and France)

15 Hours (Shi Wu Xiao Shi), 2017
16:9 film, color, sound in Chinese
Mandarin and dialect with English
subtitles; in two parts, 7 hours,
55 minutes each
Edition of 6 + 2 AP
Courtesy of the artist and Galerie
Chantal Crousel, Paris

WANG

The film is shot in a centralized garment processing facility consisting of eighteen thousand small production units employing a total of around three hundred thousand immigrant workers. They start work every day at 8 a.m., break from 11 to 12 for a lunch of beef and rice, then work from 12 to 5, and again after dinner through to 11 p.m. They usually also work on Saturdays and Sundays. Pay is on a piecework basis. Every worker, like every machine, works at top speed. We started to shoot before 8 a.m. and followed one group of workers until they clock off at night, faithfully recording their life and work through this one day.

Wang Bing

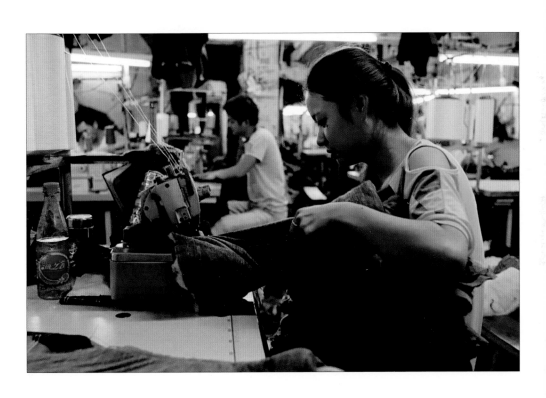

Suggestions for Further Reading
Suggestions for Further Viewing
Author Biographies

Suggestions for Further Reading

Anguelov, Nikolay. *The Dirty Side of the Garment Industry: Fast Fashion and Its Negative Impact on Environment and Society*. Boca Raton, FL: CRC Press, 2015.

Antonelli, Paola, and Michelle Millar Fisher. *Items: Is Fashion Modern?* New York: Museum of Modern Art, 2017.

Bernstein, Sara Tatyana. "That Vetements Window Display and the Trouble with Social Justice Chic," *Dismantle*, August 9, 2017, http://www.dismantlemag.com/2017/08/09/trouble-social-justice-chic/.

Black, Sandy. *The Sustainable Fashion Handbook*. New York: Thames & Hudson, 2013.

Braddock, Sarah E., and Marie O'Mahony. *Techno Textiles: Revolutionary Fabrics for Fashion and Design*. New York: Thames & Hudson, 1998.

Brown, Sass. *Eco Fashion*. London: Laurence King, 2010.

Bryan-Wilson, Julia. *Fray: Art and Textile Politics*. Chicago: University of Chicago Press, 2017.

Busch, Otto von. "Fashion suX: A Story of Anger as (Un)Sustainable Energy." *Utopian Studies* 28, no. 3 (2017): 505–27.

Busch, Otto von, and Karl Palmås. "Social Means Do Not Justify Corruptible Ends: A Realist Perspective of Social Innovation and Design." *She Ji: The Journal of Design, Economics, and Innovation* 2, no. 4 (Winter 2016): 275–87.

Cline, Elizabeth. *Overdressed: The Shockingly High Cost of Cheap Fashion*. New York: Penguin, 2012.

Fletcher, Kate. *Sustainable Fashion & Textiles: Design Journeys*. London: Earthscan, 2008.

Fletcher, Kate, and Lynda Grose. *Fashion and Sustainability: Design for Change*. London: Laurence King, 2012.

Green, Nancy L. *Ready-to-Wear and Ready-to-Work: A Century of Industry and Immigrants in Paris and New York*. Durham: Duke University Press, 1997.

Grimes, Kimberly M., and B. Lynne Milgram, eds. *Artisans and Cooperatives: Developing Alternative Trade for the Global Economy*. Tucson: University of Arizona Press, 2000.

Gwilt, Alison. *A Practical Guide to Sustainable Fashion*. New York: Fairchild Books, 2014.

Gwilt, Alison, and Timo Rissanen, eds. *Shaping Sustainable Fashion: Changing the Way We Make and Use Clothes*. London: Earthscan, 2011.

Hatcher, Jessamyn, and Thuy Linh Nguyen Tu. *All Clothes Are Handmade*. Accessed October 8, 2018. https://allclothesarehandmade.wordpress.com.

Hemmings, Jessica, ed. *The Textile Reader*. London: Berg, 2012.

Joy, Annamma, John F. Sherry Jr., Alladi Venkatesh, Jeff Wang, and Ricky Chan. "Fast Fashion, Sustainability, and the Ethical Appeal of Luxury Brands." *Fashion Theory* 16, no. 3 (2012): 273–95.

Katz, Daniel. *All Together Different: Yiddish Socialists, Garment Workers, and the Labor Roots of Multiculturalism*. New York: New York University Press, 2011.

Levine, Louis. *The Women's Garment Workers: A History of the International Ladies' Garment Workers' Union*. New York: B. W. Huebsch, 1924.

Livingstone, Joan, and John Ploof, eds. *The Object of Labor: Art, Cloth, and Cultural Production*. Chicago: School of the Art Institute of Chicago Press, 2007.

Luckman, Susan, and Nicola Thomas, eds. *Craft Economies*. London: Bloomsbury, 2018.

Milburn, Jane. *Slow Clothing: Finding Meaning in What We Wear*. Toowong, Australia: Textile Beat, 2017.

Minney, Safia. *Slow Fashion: Aesthetics Meets Ethics*. Oxford: New Internationalist Publications, 2016.

Richards, Yevette. *Conversations with Maida Springer: A Personal History of Labor, Race, and International Relations*. Pittsburgh: University of Pittsburgh Press, 2004.

Rissanen, Timo, and Holly McQuillan. *Zero Waste Fashion Design*. New York: Bloomsbury, 2018.

Rivoli, Pietra. *The Travels of a T-Shirt in the Global Economy: An Economist Examines the Markets, Power, and Politics of World Trade*. Hoboken, NJ: Wiley, 2005.

Rodabaugh, Katrina. *Mending Matters: Stitch, Patch, and Repair Your Favorite Denim and More*. New York: Abrams, 2018.

Tu, Thuy Linh Nguyen. *The Beautiful Generation: Asian Americans and the Cultural Economy of Fashion*. Durham: Duke University Press, 2011.

Suggestions for Further Viewing

Zelnik, Frederic, dir. *The Weavers*. Austria: Zelnik-Film, 1927.

Arnold, Jack, dir. *With These Hands*. New York: Promotional Films, 1950.

Mackendrick, Alexander, dir. *The Man in the White Suit*. UK: Ealing Studios, 1951.

Gordon, Michael, dir. *Pillow Talk*. USA: Arwin Productions, 1959.

Patwardhan, Anand, dir. *Occupation: Mill Worker*. Brooklyn, NY: First Run/Icarus Films, 1996.

Peled, Micha X, dir. *China Blue*. Toronto: Teddy Bear Films, 2005.

De la Torre, Sergio, and Vicky Funari, dirs. *Maquilapolis*. Netherlands: Independent Television Service, 2006.

Carracedo, Almudena, dir. *Made in L.A.* San Francisco: Independent Television Service, 2007.

Majid, Hannan, and Richard York, dirs. *The Machinists*. UK: Rainbow Collective, 2010.

Martin, Uwe H., dir. *White Gold: Texas Blues*. Denmark: Bombay Flying Club, 2011.

Gupta, Meghna, dir. *Unravel*. London: Soul Rebel Films, 2012.

Morgan, Andrew, dir. *The True Cost*. USA: Life Is My Movie Entertainment Company, 2015.

Akers, Ben, dir. *Alex James: Slowing Down Fast Fashion*. UK: Journeyman Pictures, 2016.

Jain, Rahul, dir. *Machines*. USA: Kino Lorber, 2016.

Wang Bing, dir. *Bitter Money*. New York: Icarus Films, 2016.

McIlvride, David, and Roger Williams, dirs. *RiverBlue*. Los Angeles: Paddle Productions, 2017.

Author Biographies

Bibiana Obler is associate professor of art history at the George Washington University. Her book *Intimate Collaborations: Kandinsky and Münter, Arp and Taeuber* (2014) investigates the role of artist couples in the emergence of abstract art. She is working on a second book, *Anti-Craft,* on relations between craft and art in the late twentieth century.

Kirsty Robertson is associate professor of contemporary art and museum studies at Western University in London, Ontario. She has published widely on activism, visual culture, museums, and textiles and is a founding member of the Synthetic Collective, a group of artists, scientists, and cultural researchers working on plastic pollution in the Great Lakes region.

Phyllis Rosenzweig is curator emerita at the Hirshhorn Museum and Sculpture Garden. While at the Hirshhorn, she organized many exhibitions of contemporary artists including Byron Kim, Sherrie Levine, Glenn Ligon, and Kiki Smith. More recently, she curated exhibitions at G Fine Art and American University Art Museum, both in Washington, DC, as well as BronxArtSpace in New York City.

Thuy Linh Nguyen Tu is associate professor of social and cultural analysis at New York University. She is the author of *The Beautiful Generation: Asian Americans and the Cultural Economy of Fashion* (2010) and *Consuming Skin: Experiments in Race and Beauty Across the Pacific* (forthcoming). Her writing has also appeared in *American Quarterly, Women's Studies Quarterly,* and *n+1,* among other publications.

Text and photography © 2019
Bowdoin College

Book © 2019 Scala Arts
Publishers, Inc.

This research was supported
by a Craft Research Fund grant
from the Center for Craft.

 Center for Craft

Published on the occasion
of the exhibition *Fast Fashion /
Slow Art*, organized by the
Bowdoin College Museum
of Art, Brunswick, Maine in
cooperation with the Corcoran
School of the Arts and Design
at the George Washington
University and the George
Washington University Museum /
Textile Museum, Washington,
DC. On view in the historic
Flagg building of the Corcoran
School of the Arts and Design,
Washington, DC, August 8–
December 15, 2019; the
Bowdoin College Museum
of Art, Brunswick, Maine,
January 30–August 2, 2020.

First published in 2019 by
Scala Arts Publishers, Inc.
c/o CohnReznick LLP
1301 Avenue of the Americas
10th floor
New York, NY 10019
www.scalapublishers.com
Scala – New York – London

Distributed outside Bowdoin College
in the book trade by
ACC Art Books
6 West 18th Street
Suite 4B
New York, NY 10011

ISBN 978-1-78551-223-0

Cataloguing-in-Publication Data is
available from the Library of Congress.

Edited by Magda Nakassis
Designed by Antonio Alcalá and
Ricky Altizer of Studio A
Printed in China

10 9 8 7 6 5 4 3 2 1

Front cover:
(top) Still from *Planet Money Makes
a T-Shirt*, 2013, interactive website
© 2013 National Public Radio, Inc.
Photo credit: David Gilkey/NPR (see
pages 50–51).

(bottom) Still from Rosemarie Trockel,
Yvonne, 1997, video, black-and-white
and color, sound, 14 minutes. Galerie
für Zeitgenössische Kunst Leipzig.
© 2019 Artists Rights Society (ARS),
New York / VG Bild-Kunst, Bonn;
courtesy of GfZK Leipzig (see pages
58–59).

Frontispiece:
Cat Mazza, work in progress for
Fast Fashion / Slow Art video
installation (image altered), 2018.
Photograph courtesy of the artist
(see pages 44–47).

Page 2: Detail (altered) from page 51.

Page 6: Detail (altered) from page 12.

Page 18: Detail (altered) from page 19.

Page 26: Detail (altered) from page 33.

Page 36: Detail (altered) from page 11.

Page 62: Detail (altered) from page 57.